The Cathedral Is Dying

David Zwirner Books

ekphrasis

The Cathedral Is Dying
Auguste Rodin

Translated by Elisabeth Chase Geissbuhler

Contents

Introduction

Rachel Corbett

Just days after flames engulfed Paris's Notre Dame Cathedral, on April 15, 2019, a billion dollars in donations poured in to finance its restoration. But that was the easy part. What remains now is the formidable task of deciding how the restoration should look, and what it really means to "rebuild Notre Dame even more beautifully" than it was before, as French president Emmanuel Macron has promised.

Architects are now wrangling over whether to modernize the burnt wooden roof with contemporary building materials or to reconstruct it in the original wood. Should they update the Gothic spire with a new look, or replicate its pre-blaze state—even though that was itself a reproduction of an earlier spire, added to the cathedral in the nineteenth century?

These concerns aren't new to Notre Dame. A strikingly similar debate took place more than a century ago when France commissioned the audacious thirty-year-old architect Eugène Viollet-le-Duc to restore the cathedral, which had been crumbling since the ravages of the French Revolution. Viollet-le-Duc's critics denounced the architect's habit of inscribing his own flourishes onto the cathedrals he restored, details that he claimed medieval builders would have added themselves if only they'd had the technological capabilities at hand.

At Notre Dame, he carved a new oak pulpit and replaced some of the medieval sculptures with modern ones. And instead of replicating the original thirteenth-century spire, which had been removed decades earlier

due to disrepair, he designed a new one. The spiky wooden flèche, coated in protective lead, was modeled on what Viollet-le-Duc believed was a more impressive spire, at the cathedral in Orléans. At three hundred feet tall, Notre Dame's new spire soared above its original and, from its broadened base, descended a new series of sculptures of the twelve apostles, one of whom— Thomas, the patron saint of architecture—bears the likeness of Viollet-le-Duc himself.

Perhaps no one more passionately opposed this revisionist architecture than Auguste Rodin. The French sculptor decried the heavy hands of his era's cathedral restorers in a 1909 editorial in the newspaper *Le Matin*, titled "A National Sacrilege: We Are Letting Our Cathedrals Die." Rodin argues that it was far better to allow cathedrals to deteriorate naturally than for them to be mutilated by restorers ignorant of the "secret" of Gothic design, which he describes as the harmony of opposing planes; the delicate distribution of light glancing across reliefs, carved neither too deep nor shallow; the dance of chiaroscuro as the sun highlights and darkens figures throughout the day.

"The soul of Gothic art," Rodin writes, lies in the "voluptuous declension of light and shadow which gives rhythm to the entire structure and makes it live. Here is a knowledge now lost, a deliberate ardor, controlled, patient, and strong, which our greedy and restless century is incapable of understanding."[1] Restorers incorporated into cathedrals "the vices of our epoch," and "they always

tend to overload the structure, to weary it. They miss the effect they strive for because they do not know the requirements of equilibrium."[2]

It wasn't only Viollet-le-Duc's "so-called restoring of Notre Dame" that horrified Rodin. It was that this kind of vandalism had "humiliated" great cathedrals across France—in Reims, Chartres, Mantes, and beyond. That's why Rodin, in his seventies, set out to preserve the cathedrals himself, in the only way he knew how: by looking at them closely and drawing them for posterity. He hired the writer Charles Morice to help compile his notes and drawings into a book, *Les Cathédrales de France*, published in 1914.

The book, four chapters of which are included in these pages, is part anti-restoration jeremiad, part love letter to the art of the Gothic cathedral. It is an attempt to inspire others "to come to the rescue of as much of it as still remains intact; to save for our children the great lesson of this past which the present misunderstands," as Rodin writes in the first chapter. He implores readers to appreciate the cathedral both as a painting, done in the medium of light and shadow, and as a figurative sculpture, as balanced and proportioned as the human body.

To Rodin, Gothic cathedrals not only resemble the human form—with a central vault for the heart, protective ribbing, and flying buttresses that reach out like arms—they are also mortal and age over time. In denying their living nature, restorers treat them like objects, their axes and chisels deepening their wounds rather

than healing them. "For living stones, scattered among bric-a-brac, dead things are substituted," Rodin writes.[3] "No architect or sculptor has ever been able to properly restore a Gothic church or cathedral."

Cathedral architecture was central to the way Rodin approached his own sculpture. Like nature, the cathedral "also knows that perfect equilibrium of volumes is sufficient for the beauty and even for the grace of superior beings; she grants them only the essential. But the essential is all!"[4] Rodin writes. Generations of anonymous cathedral builders laid stones over entire lifetimes, never receiving recognition for their work nor seeing it complete. This was the ultimate act of devotion, Rodin thought, and he took that principle with him as he set out at the beginning of his career as a carver of stone ornaments for buildings. Each time he chiseled a leaf, for example, he viewed it as a tiny act of devotion to his god— nature. "Where did I learn to understand sculpture? In the woods by looking at the trees, along roads by observing the formation of clouds ... everywhere except in schools," he notes.[5]

The tragic irony of Rodin's devotional book is that the bombs of World War I started falling the year it came out, laying waste to some of the very same cathedrals he had sought to preserve in the volume. When Rodin learned that the Germans had all but reduced the cathedral at Reims to rubble, he turned white in the face and said that, in the future, "one will say 'the fall of Reims' as one says 'the fall of Constantinople.'"

But Rodin may have taken some comfort in his own words, and his belief that, when it comes to a cathedral, "strokes of violence are not mortal. They must be condemned.... But against an absolutely beautiful work, the vandal cannot prevail unless he reduces it to dust."[6]

We, too, might remember Rodin's wisdom today as we mourn the devastation of Notre Dame. Its spire and two-thirds of its roof collapsed, but even a nine-hour inferno did not reduce it to dust. Its two stone towers and rose windows endure, as do its essential planes. Its body is scarred but its soul is intact. And for that reason it deserves more than ever to be seen, studied, and admired, in all its flaws and advancing age. Perhaps it is time to make a pilgrimage to those old stones, to humble oneself before them as Rodin would have done, and pore lovingly over their surfaces. Perhaps that is how we make the cathedral even more beautiful than before.

1 From the chapter "Initiation into the Art of the Middle Ages," in Rodin's *Cathedrals of France*. This volume, p. 36.
2 From the chapter "The French Countryside," in Rodin's *Cathedrals of France*.
3 "Initiation into the Art of the Middle Ages"; this volume, p. 33.
4 "Initiation into the Art of the Middle Ages"; this volume, p. 20.
5 "Initiation into the Art of the Middle Ages"; this volume, p. 26.
6 "The French Countryside."

Translator's Note

Elisabeth Chase Geissbuhler

In this translation, whose purpose is fidelity to Rodin, only typographical ambiguities have been considered for possible change. One, but not the only one, concerns Rodin's personal capitalization.

As others underline words that reveal their passions, Rodin capitalized, but not invariably, those that stood for what he loved and, to a lesser extent, for what he abhorred. Of themselves these words indicate, as all Rodin's notes affirm, that he deplored the vices of the dawning industrial age: the denatured, mechanical, and systematic; while he adored all things of Nature and all that men make in loving obedience to her laws. Words also capitalized by religious writers, such as "Spirit" and "Grace," "Virgin" and "Mother," Rodin capitalized in reference to art and to Nature, while never precluding their religious significance. This was inevitable, since for him all art was sacred because its source, Nature, was sacred. Yet the word "art" is never capitalized in Rodin's writing.

The constancy with which that vital word is kept in lower case, contrasting with the inconstancy of his capitalization of all other words, may be understood as Rodin's refusal to elevate art separately from the transcendent Nature he venerated. Concerning the Romanesque he wrote: "Nothing is invented or willed by men who could have willed differently. All is interrelated. Creators are beings more obedient than others." Obedient, that is, to "Nature and her laws." Thus it is clear that obedient "art" should never be capitalized. But does it not follow that "Nature" always should be?

Unlike "Spirit" and "Grace"—capitalized alike when Rodin means gracefulness and one spirit continuing through the various art styles, as well as the Holy Spirit— the noun "Nature" in his writing always means the source of all art able to endure, thus always meriting his emphasis through capitalization.

In three articles he wrote for *Le Musée*, "Nature" is capitalized without exception, and in one four-page article, it occurs fifteen times. In this book, by contrast, "Nature" is capitalized only twelve times, and once is both capitalized and uncapitalized in the same sentence. In French, where there is normally less capitalization than in English, surely such inconsistency would have been corrected along with Rodin's spelling mistakes, had not editor, copy editor, and printer, warned of the great man's personal usage, been intimidated; they were not alone in this.

Both before and after 1910, when Charles Morice began assembling this book, Rodin's notes were passed among his admirers, many of whom were writers, and who might have made corrections. But comparison shows that however much he asked for help, Rodin firmly resisted change. We believe in the effectiveness of that resistance, we who are warned: "The laws that I express are those of instinct; they have no need of grammar, that children's nurse." With such warning who would reason with enigmas and risk falling into error far worse in Rodin's sight than inconsistency, the error of systematic capitalization, comparable to the sort of restoration

by receipt that Rodin abhorred? Instead, everyone seems simply to have copied, as much for the original 1914 edition as for each one of the reprintings.

And after all, in this book made primarily of Rodin's private notes, it seems not unnatural to find words variably capitalized whose meaning and importance for himself Rodin's capitalization had established. So, however reluctantly for the word "Nature," Rodin's capitalization is followed here even to the omission of capitals for words he had previously capitalized, leaving the alerted reader free to make his own consistency.

E.C.G.
1965

Initiation into the Art of the Middle Ages

PRINCIPLES

Cathedrals impose a sense of confidence, of assurance, of peace. How? By their harmony.

Here a few technical considerations are needed.

Harmony in living bodies results from the counter-balancing of masses that move. A Cathedral is built on the principle of living bodies. Its concordances, its equilibriums, exactly follow general laws according to nature's order. The great masters who erected these monumental wonders had complete knowledge of the science of their art and were able to apply it, having drawn it from its natural, original sources, because that science had remained alive in them.

Everyone knows that the human body, as it moves, changes its bearing and that equilibrium is reestablished through compensations. The leg that carries the weight when it comes directly beneath the body is the body's only pivot and makes, during that instant, the whole and unique effort. The leg that does not carry serves only to modulate the degrees of the stance, modifying the shift slowly, or rapidly if need be, until a new equilibrium is substituted, liberating the leg which bore the weight. In popular workingman's language this is called "untiring oneself," by shifting the body's weight from one leg to the other, just as a bearer might change his burden from shoulder to shoulder.

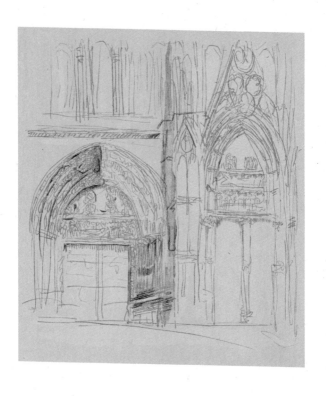

Mantes

These indications are not without importance in relation to Cathedrals. The compensating movements, those perpetual and unconscious gestures of life, explain the principle that architects have applied in their flying buttresses which they needed to hold up solidly the enormous weight of their roofs.

And, as every rational application of a true principle has fortunate consequences in all domains beyond the immediate expectations of scholars and craftsmen, the Gothics were great painters because they were great architects. (It goes without saying that we use the word painter here in a large and general sense.) The colors in which these painters dipped their brushes are the light and shadow of day, and of the two twilights. The planes obtained by the great contrasts that the Cathedral builders had to find are of interest not only as equilibrium and solidity; they determine, besides, those deep shadows and beautiful blond areas that give the building so magnificent a vesture. For all holds together, the least element of truth evokes the truth as a whole, and the beautiful is not distinct from the useful, no matter what the ignorant may believe.

Those great shadows and great lights are carried solely by essential planes, the only ones that count from afar, the only ones that are not thin and weak because in them the half-tone dominates. And despite their power, or rather because of that power, those lines, those planes, are simple and without ponderance. Let us not forget that power brings forth grace; there is perversion of taste

or perversity of mind in looking for grace in weakness. The details are designed to charm from nearby and to swell the contours from a distance.

Only effects of such intensity as this could carry to great distances. Thus the Cathedral arose to dominate the city assembled about her, as though under her wings, to serve as a rallying point, as a refuge to pilgrims lost along distant ways, to be their lighthouse, to reach living eyes during the day as far as the Angelus and Tocsin could reach living ears during the night. Nature also knows that perfect equilibrium of volumes is sufficient for the beauty and even for the grace of superior beings; she grants them only the essential. But the essential is all!

Thus the vast planes of Gothic monuments are engendered by the meeting of diagonal ribs which constitute what are called ogival arches. What elegance is in these simple and so powerful planes! Thanks to them, light and shadow react upon one another to produce halftones, the principle of the opulent effect we admire in these mighty structures. This effect is entirely pictorial.

Here we have been led to speak first of painting in treating of architecture. Indeed this play, this harmonious use of night and day, is the end and the means, the very object and justification of all the arts. Is it not the whole task of architecture, that most intellectual and most sentient of the arts, the one which most completely requires all human faculties? Not in any other art do invention and reason take so active a part, but architecture

is also the most narrowly ruled by the laws of atmosphere in which monuments are ceaselessly bathed.

The architect, as he works according to the laws that govern light and shade and according to his own intentions, has at his disposal only certain combinations of geometrical planes. But what immense effects he obtains by means so slight! May it be that in art effects are proportionately greater as means are more simple? Yes, since the supreme aim of art is to express the essential. All that is inessential is foreign to art. The difficulty is to untangle the essential from the nonessential. The more abundant the means, the more complex the difficulty, the more it becomes a delicate matter to do justice to the shades, the degrees of light that change hour by hour, without violating their natural liberty or betraying the thought one proposes to express.

Are not these supreme aims of architecture also those of sculpture? The sculptor who chooses his models from among living forms, from vegetables or animals, men or women, is indeed admirably served by the infinite variety of all that beauty; but this variety may also become a danger to him. He attains full expression only by devoting his whole study to the harmonious play of light and shade, exactly as does the architect. In the final analysis then, it is always by light and shade that a sculptor as well as an architect shapes and models. Sculpture is but one species in the immense genus of architecture, and we should never speak of sculpture without subordinating it to architecture.

How "masterpieces" are "masterpieces" I know, and what joy I have in knowing! In exactly the same way great souls are great souls. It is by rising to what is indispensable in the expression of their thoughts and feelings that both man and artist worthily fulfill themselves. A masterpiece is of necessity a very simple thing which comprises, I repeat, only the essential. All masterpieces would be quite naturally accessible to all men if they had not lost the spirit of simplicity. And even today, when people have become incapable of understanding, it is still with popular feeling, with a "soul of the crowd," that an artist must live to be able to produce a masterpiece. He must feel with the crowd, be it but ideally present. He must understand this as the masters did. For the masters themselves became "crowd" in order to reclaim by the heart, by love, what they had discovered by intellect.

Gothic architecture, built in anticipation of the multitude and destined for the multitude, speaks the grand and simple language of masterpieces. The Cathedral guides light and shadow and governs them by means of the planes that receive those values. When one of two opposing planes is in light, the other is in shadow. Two such planes, already vast in themselves, grow greater still through opposition. The Antique is expressed by more shallow planes than the Gothic. Gothic planes are equal in value to the thickness and depth of their construction. But deep Gothic shadows are always mellow because they are maintained in the overall half-tone, that glancing luminosity which is the sun's loving caress.

There is little black in the Cathedrals. Black is used as a bold stroke which works destined to be seen in the open air do not seem to need. Our modern architects abuse the use of black; this is why all they make is so hard, so thin, so weak. The Renaissance style, which derives from the Gothic, uses black only as a mark of emphasis, while the half-tone dominates everywhere. Further, the bias plane of the arches, the flaring bell shape of the porches, the protruding frontal abutments, and in general all those planes that are in oblique relationship to the axis of the Cathedral, serve at once to enrich, to emphasize the unity of its grandeur and to produce the half-tone. One finds these oblique planes in the bas-reliefs, and even in the sculptured figures of arched doorways; this procedure is universal in the Gothic way of working, which accounts for the fact that the same sensitive and intelligent softness, accompanied by the same energy, prevails throughout.

I should like to inspire a love for this great art, to come to the rescue of as much of it as still remains intact; to save for our children the great lesson of this past which the present misunderstands.

In this desire I strive to awaken intellects and hearts to understanding and to love.

But I cannot tell all. Go and see. And above all, observe with a docile simplicity, consenting to work and to respect.

Let us study together.

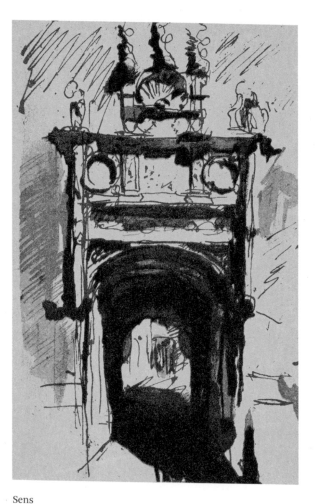

Sens

II

Where shall we begin?

There is no beginning. Start where you arrive. Stop before what first entices you. And work! You will enter little by little into the entirety. Method will be born in proportion to your interest; elements which your attention at first separates in order to analyze them will unite to compose the whole.

In the calm exile of work, we first learn patience, which in turn teaches energy, and energy gives us eternal youth made of self-collectedness and enthusiasm. From such vantage we can see and understand life, this delicious life that we denature by the artifices of our enclosed, unaired spirit, surrounded though we are by masterpieces of nature and of art. For we no longer understand them, idle despite our agitation, blind in the midst of splendors.

If we could but understand Gothic art, we should be irresistibly led back to truth.

How true, just, and fertile was the method of our old masters of the eleventh to the eighteenth centuries, a method which, in general and in union with all human forces of an epoch, is that of our own individual activities when they are well directed: the perpetual collaboration between man and nature.

Where indeed must this knowledge be sought? Everywhere. Look for it in the least, as in the greatest, of life's events, in our instinct as well as in our thinking.

Often one learns the most from things of modest

appearance. Work is mysterious. It grants much to those who are patient and simple; it refuses those who are hurried and vain. It accords to an *apprentice* what it denies to the *pupil* of a school; and on a certain day the marvel is born out of the hands of a humble workman.

Where did I learn to understand sculpture? In the woods by looking at the trees, along roads by observing the formation of clouds, in the studio by studying the model, everywhere except in schools. And what I learned from nature, I have tried to put into my works.

By this means Gothic genius, after using the forests and the rocks, introduced into its masterworks the gardens, orchards, espaliers, and all the friendly farm vegetables, as well as all legends loved by the poor, together with all the most delicate details and most sublime episodes of life. And not content with borrowing from nature's beauties through constant, humble, and passionate toil in order to compose a festival of days, Gothic genius also assimilated the laws of natural creation to renew and perpetuate that festival by giving it variety. This is the sound method which enabled Gothic genius to express faint differences without contradicting itself and to continue to charm new generations.

Such variations are the transitions from one style to another.

With what supple grace, what wealth of invention, French genius moves from epoch to epoch to introduce a new phase in its architectural style! It disturbs nothing that already exists; it in no way contradicts the principles

of the accomplished phase. *Order is followed* just as nature herself draws fruit from a flower. This is a transmission of life.

Both flower and fruit were models for the Gothics. One learns much by studying sequences, correspondences, and analogies—for the same law governs moral and emotional life—provided one already has an understanding of this general law. The Gothics had that understanding. But such discoveries are rewards. One obtains them only after many struggles, many steps over a long road, not counting detours made along side paths or meditative halts at crossroads.

Gothic art produced the French Renaissance by deducing from clear Gothic principles their consequences. Or to say that more accurately, the Renaissance is a Declension of the Gothic. It is, just as truly, the same Force which begets Grace and Spirit; it is a dream in several joyous tenses. The jubilant spirit uncoils into ornaments like a snake in the sun.

What a country this is to have possessed such vitality!

And to have conserved that vitality until our day of lassitude and lies when people consider adulterating old stones as well as old wines.

III

I know that at the present time man is suffering; he invokes a change. A whole new world is stirring of which we know nothing, perceiving neither its proportions, its

bounds, nor its harmony. Does Orpheus preside over the birth of this new world, or only that ancient Python who always expects to triumph over the eternally youthful Apollo?

However it may be, man has already known many changes before our time, and he has always known how to pass through them without sacrificing the past to the future. For all the weight of centuries, the Sphinx and the temples still raise their profiles of august serenity against the horizon. After Egypt and Greece, Rome has left everywhere the indelible imprint of its enduring and proud character.

Why has French architecture been tampered with?

Even today I can still see the Arena at Nîmes, but our Cathedrals are already more than half obliterated! Greece has indeed been mutilated but its sorrows and its wounds do not dishonor it. France has been slandered and reviled. That magnificent stone vesture, which might have been able to defend it against the future, has fallen into tatters at the merchants', and the odious fact neither irritates nor surprises anyone.

Will the genius of our race end by passing away like those pale ghosts and vanished forms that no one seeks anymore? Was it in historical or mythical time that the Cathedral, rowing through space by its buttresses, all sails unfurled, the French ship, the French victory, beautiful as for Eternity, spread open at its apse the wings of a group of kneeling angels?

No one defends our Cathedrals.

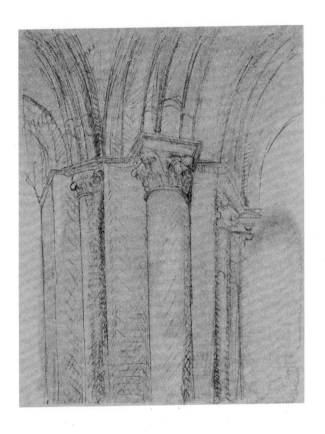

Champeaux

The burden of old age crushes them, and under the pretext of curing them, of "restoring" what he should only uphold, the architect changes their features.

Crowds stop in silence before the Cathedrals, incapable of understanding the splendor of these architectural immensities, yet instinctively admiring them. Oh, the mute admiration of these crowds! I want to cry out to them that they are not mistaken; yes, our French Cathedrals are very beautiful! But their beauty is not easy to understand. Let us study them together; understanding will come to you as it has come to me.

And the means of understanding are all about you. The Cathedral is a synthesis of our country. I repeat: the rocks, forests, gardens, Northern sun, all these are condensed in this gigantic body. All of our France is in our Cathedrals, just as all of Greece is summarized in the Parthenon.

Alas, we are at the evening of their great day. These forebears are dying, martyred.

Renan prayed on the Acropolis. Is no one tempted to praise you also, to protect you, French marvels, Chartres, Amiens, le Mans, Reims? Have we then no new poet to pray over our Cathedrals, those dolorous virgins, all stricken, yet all still sublime?

But architecture no longer touches us. The rooms in which we consent to live are without character. They are boxes crammed helter-skelter with furniture. Everywhere the "Conglomeration" style reigns. How can we understand the profound unity of the great Gothic symphony?

Those admirable workmen who, for having directed

their thought to heaven, were able to fix its image upon earth, are no longer here to preserve their work. Day by day time steals a bit of its life, and restorers, by making a mockery of it, plunder its immortality. Evil days have come. Even such minds as a pure instinct inclines toward admiration are not sure of understanding. Let us not blush for our lack of understanding! May our glory be in striving to understand. I declare to you that our architecture was the marvel of our marvels, the one among all which would have been worthy of universal admiration and gratitude, had we not dishonored it. Why indeed, when France will have gone into eclipse, her reign ended, may she not look forward to being judged by future generations according to her works and her merits? It would have been so fine to die as Greece died, to set like the sun inundating the world with light!

We shall have had neither the happiness of Athens, dying in its glory, nor that of Rome, leaving everywhere the ineradicable trace of its power.

The Gothics set stone upon stone, ever higher, not, as the giants did, to attack God, but to reach up to Him. And God, as in the German legend, rewarded the merchants and the warriors, but to the poet, what was granted?

"Where were you at the time of the distribution? I did not see you, poet."

"Lord, I was at your feet."

"Then sometime you shall come up beside me."

Thus it was the poet who guided the masterbuilder, and in reality the poet built the Cathedral.

Study

The Cathedral is dying and with it the country, stricken and outraged by her own children. We can no longer pray before the humiliation of our supplanted stones. For living stones, scattered among bric-a-brac, dead things are substituted.

And yet, I cannot despair.

They still possess, despite all things and all persons, so much beauty, our old living stones! None has succeeded in killing them, and it is our duty to gather together and defend these relics.

Before I myself disappear, I wish at least to have told my admiration for them. I wish to pay them my debt of gratitude, I, who owe them so much happiness! I wish to honor these stones, so lovingly transformed into masterpieces by humble and wise artisans; these moldings admirably modeled like the lips of a young woman; these beautiful lingering shadows where softness sleeps at the heart of power; these delicate and vigorous ribs springing up toward the vault and bending down upon the intersection of a flower; these rose windows whose magnificence was inspired by the setting sun or by the dawn.

To understand Cathedrals one must be sensitive to the moving language of their lines, amplified by shadows and reinforced by the graduated form of their adorned or unadorned buttresses. To understand these lines, tenderly modeled and caressed, one should have the good luck of being in love.

It is impossible to be insensitive to the magic and virtue of all this splendor. What reserve of power and of glory might the new world find here? Though you transform the world according to your taste, there is at least one thing that will not change: that is the law which governs the relationship between light and shade and which, in their oppositions, creates harmony. The Gothics, following the Romans, understood that law.

When their masterpieces are no longer before our eyes, there will be nothing to remind us of that law.

When the death agony of our Cathedrals has been accomplished, our country will be transformed, dishonored—at least until that far-off time when human intelligence reascends to the eternal Beatrice.

IV

Who will come with me?

I am not traveling to Italy or elsewhere. For me, from my present point of view, the sky is the most important landscape. The sky reigns over all things, forever changing their aspect and making new spectacles of the most familiar sights.

And in fact, because I myself have changed, I find novelty in sights that are familiar, and beauty in forms that I did not understand before. My transformations come above all from my work: having studied ever more assiduously, I may say that I have ever more ardently and more lucidly loved.

As a young man, of course, I loved the Gothic lace-

work, but now I understand the part it plays, and I admire the power of that lace. It rounds out the profiles and fills them with sap. Seen from a distance, those profiles appear as delightful caryatids that cling to the framings like the vegetation that molds the severe line of a wall or console brackets that lighten the heaviness.

Little by little I have come to our old Cathedrals and have been able to penetrate the secret of their life as it is constantly renewed beneath the changing sky. Now I can say that I owe them my greatest joys.

Romanesque, Gothic, Renaissance! I know now that several long lives would not suffice to exhaust the treasures of happiness that our monuments of the past reserve for the sincere lover of beauty. And I am faithful to them. How often the snow, the rain, and the sun find me standing before the Cathedrals, like a French migrant worker.

In my pilgrimages I have had but few companions. Those I had were neither architects, sculptors, poets, priests, nor men of State, but foreigners who were verifying the statements of Baedeker.

Oh, why do you not recognize your true advantages? Why do you despise your good fortune?

Come let us study! Come and receive true life from those who are no more, but who have left us such magnificent testimony of their souls!

At each visit they tell me new secrets. They have taught me the art of using shadows as they should be used to envelop a work, and I have understood the lesson

they give us in those full outlines which they always use. *The Cathedrals of France are born of the French countryside.* Our air, our sky, at once so clear and so soft, gave our artists their grace and refined their taste. The lark, national bird of France, alert and graceful, is the image of their genius. The lark abandons himself to the same flight, and the soaring of the stone lacework, like the wings of that bird, becomes iridescent in the silver-gray air.

Do you suppose, when the Druidic majesty of the great Cathedrals rising in the distance astonishes you, that they are the result of natural, fortuitous causes, such as their isolation in the country? You are mistaken. The soul of Gothic art is in this voluptuous declension of light and shadow which gives rhythm to the entire structure and makes it live. Here is a knowledge now lost, a deliberate ardor, controlled, patient, and strong, which our greedy and restless century is incapable of understanding. We must relive the past, return to principles in order to recover that strength. In those days a discerning taste ruled our land: we must become French once more! Initiation to Gothic beauty is initiation to the truth of our race, of our sky, of our land.

Soissons at Evening

There is no time in this Cathedral; there is eternity. Does not Night bring it more harmony than day? Were the Cathedrals made for the night? Does not triumphant day, inundating them with clarity, too completely subdue them?

Ah, beauty of which I had foreboding! I am fully satisfied. Restorations which offended my eyes in daylight are now effaced. What an invincible impression of virginity! This flower of the catacombs is a virgin forest illuminated by powerful lights springing from one of the lateral naves.

Yes, it is at night, when all the earth is in obscurity, it is then, thanks to a few gleams, that architectures *revive*; it is then that they retrieve all their august character, as the sky regains all its grandeur during starlit nights.

Therefore I had a rendezvous last night with the image of heaven that I hold in my heart, with this heaven that shall have no morrow, perhaps. Why must this divine Cathedral be insulted? Why must this *Ecce Homo* of stone be turned to derision? And yet, during the moments that I, atom of life, spend in this Cathedral, I feel myself imbued with past centuries, the venerable centuries that produced these marvels. They are not dead! They speak in the voice of the bells! These three strokes for Angelus that sweetly strike against the sky know no obstacle or limit either in space or in time; they come to us out of the depths of the past, they rejoin our Chinese brothers and the deep vibration of the gong.

First this lordly ringing is as if the gods conversed; then it is a thrumming, like an assembly of women

speaking all at one time; finally, the voice of the bell fades slowly and expires, powerful still over this gentle provincial city whose soul is a daughter of honorable simplicity, whereas Paris is the international daughter of pride.

These arcades that catch the light among shadows are in ruins. With them the spirit rests suspended in the air and in time.

In the light that strikes them, the columns are a white cloth with straight folds, the rigid folds of a sacerdotal surplice. But when they are fully lighted, they evoke parading soldiers in a respectful attitude whose straight alignment nothing will flex. And then the flame weakens, and the columns appear to be ghosts.

Exterior.
In this silent square, in the immobility of night, the Cathedral has the air of a great ship at anchor.

Rain, which for centuries has poured its gusts over these stone laces, has still further whittled and perfectioned them. How far away is the time when these marvels were new! The Gothics are now as far from us as the Greeks.

All the kings of France are in this shadow, in this majestic tower that overhangs.

Day breaks. Light foregathers; it reaches the Cathedral by wide strokes, splatters the master columns, the small openwork columns, the lost profiles of the light, torus moldings. Brief half hour of delights.

Étampes

Reims

The Cathedral is here, motionless, mute; I do not see it in the blackness of night.

As my eyes grow accustomed, I make out a little. What appears to me is the great skeleton of all the France of the Middle Ages.

This is a conscience. We cannot escape from it. It is the voice of the past.

The artists who built this Cathedral brought the world a reflection of divinity; they added their souls to ours that we might grow, and their souls belong to us. They are our soul in all the best that we have.

And we are being diminished by allowing the work of those ancient masters to perish. The artist who witnesses this crime feels himself grazed by remorse.

But the part which still remains intact retains the life of the work as a whole and defends our souls. In these ruins we have our last sanctuary. In the same way the Parthenon has defended Greece better than the shrewdest politicians could. It continues to be the living soul of a vanished people, and the least of its fragments is the Parthenon as a whole.

Seen from the three-quarters view, Reims Cathedral evokes the enlarged figure of a woman kneeling in prayer. This meaning is suggested by the form of the console.

From the same point of view, I observe that the Cathedral rises like flames.

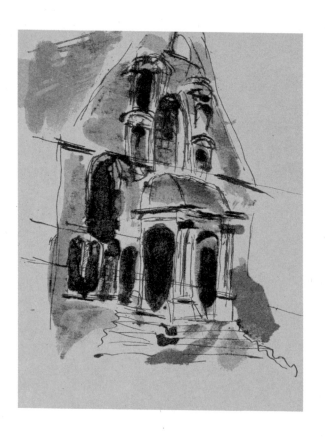

Dijon

And the richness of its profiles makes it an endlessly varied spectacle.

In studying a Cathedral, one has all the surprises, all the joys, of a beautiful journey. Such joys are infinite.

Nor do I presume to describe to you all the beauties of Reims Cathedral. Who indeed would dare to boast of having seen them all? I give only a few notes.

My aim, do not forget, is to persuade you in turn to follow this glorious itinerary: Reims, Laon, Soissons, Beauvais.

Through my open window the great voice of the bells reaches me. I listen attentively to this music, as monotonous as its friend the wind that brings it to me. I seem to hear in it at once echoes from the past, from my youth, and the answers to all the questions that I never cease to ask myself, questions which throughout my life I have sought to resolve.

The voice of the bells follows and outlines the movement of clouds; over and over it dies and is reborn, weakens, revives, and, in its immense call, the street noises, the grinding of carts and the morning cries, are lost. The great maternal voice dominates the city and becomes the vibrant soul of its life. When I had ceased to listen I heard it still, and, suddenly reminded, I give it ear again; but it is beyond, it is to the people down there that the bells are speaking now. It is as if a prophet in the open air were turning this way and that way, toward the right and toward the left. The wind has changed.

But those are the centuries, and not the hours, that the bells of our great Cathedrals are tolling.

It is true that they also ring for festivals, religious festivals. Which one is for today? What a chasm that simple questions opens between the Cathedral itself and the questioner! Can anyone imagine a man of the thirteenth century asking, "Which festival are the bells proclaiming today?" Be interrupted ariel voices, nor let your call come so far as our ears. Let it fly away into the azure.

Suddenly I hear, "What a heap of rubbish!"

A little boy is passing with his mother close to the Cathedral and pointing to pieces of old stone carelessly stacked, old fragments of ancient sculptures that the architects have left in the workyard, all of which are masterpieces.

The young woman is delicately featured and fresh, like the statues that adorn the Cathedral. She did not reprimand the child.

From where I am, I see the radiating chapels of the apse. I glimpse this only through a curtain of old trees made bare by winter. The flying buttresses and the trees intermingle and harmonize. They are in the habit of living together. But can springtime reanimate these stones as it does those trees?

The profusion of three-storied arches in perspective makes one think of Pompeii, of those paintings where branches and arches are also blended.

I am perhaps more shocked by the restorations here than anywhere else. They date from the nineteenth century, and, in the fifty years since they were made, though they have gathered a patina, they deceive no one. These half-century-old ineptitudes would place themselves among the masterpieces!

All restorations are copies; this is why they are condemned in advance. For—allow me to repeat—one must not copy with the passion of fidelity anything other than nature: the copying of works of art is forbidden by the very principle of art.

And restorations—on this point also I wish to insist again—are always soft and hard at the same time; you will recognize them by this sign. This is because science is not enough to produce beauty; there must also be conscience.

Besides, restoration involves confusion by introducing anarchy in the results. True effectiveness hides the process; to obtain true results requires much experience, long perspective, and the science of the centuries.

See, for example, the right gable of the pediment of Reims. This has not been retouched. From this powerful block emerge fragments of torsos, draperies, massive masterpieces. A simple observer, even without clearly understanding, can, if he is sensitive, experience the thrill of enthusiasm. These pieces, broken in places like those of the British Museum, are, like those also, entirely admirable. But see how the other gable, restored, remade, is dishonored. The planes no longer exist. It is

heavy, worked frontally, without profiles, without equilibrium of volumes. For the Cathedral, which leans forward, this gable is an enormous weight with no counterbalancing weight. Oh, this Christ on the Cross, restored in the nineteenth century! The iconoclast who believed he had ruined the gable did it no great harm. But the ignorant restorer! Look again at these crawling hook-shaped leaves that have forgotten how to crawl; by such heavy restoration the equilibrium is changed.

As if it were possible to repair these figures and ornaments battered by the centuries! Such an idea could be born only in minds that are strangers to the nature of art and to all truth.

Why did you not choose the lesser of two evils? It would have been less expensive to leave these sculptures as they were. All good sculptors will tell you they find in them very beautiful models. For it is not necessary to hold to the letter, it is the spirit that matters, and this is clearly seen in these broken figures. Let your unemployed work somewhere else; they will be just as well satisfied, since it is not a certain work they are after, but the profit it brings.

They have cruelly assailed Reims. As soon as I entered, my eyes were wounded by the stained-glass windows of the nave. Needless to say they are new. Flat effects!

And these capitals, also rebuilt, representing branches and leaves; their color is uniform, flat, ineffective because the workmen held the tool frontally, at right angles to the plane of the stone. By this means one obtains only hard, unvaried results, as well say, no results.

The secret of the old sculptors, on this point at least, is indeed not very complicated and would be easy to recapture. They held the tool obliquely, which is the only way to obtain modeled effects, to have slanted planes that accentuate and vary the relief.

But our contemporaries have not the least concern for variety. They do not feel it. In these capitals composed of four rows of foliage, each row is accented as much as each of the other three. Therefore the whole looks like a common wicker basket.

Whom could we convince that we are progressing? There are epochs over which taste reigns, and there are others—like this present time.

So far as a general taste is concerned, meaning a beautiful vulgarization of pure instinct, I fear this may be no more than an attribute of races in their youth; with age their sensibility becomes blunted; intelligence sags. How explain otherwise than by a weakening of the intellect the case of these pretended artists—architects, sculptors, stained-glass workers—who make such restorations even while they have before their eyes the marvels that fill the Cathedrals? Their windows are in linoleum, rug windows, without depth.

The beautiful neighboring things cost the good companions of six hundred years ago less trouble. See this bouquet of flowers so French in quality!

Oh, I beg of you, in the name of our ancestors and for the sake of our children, break no more, restore no more!

You who indifferently pass by, but who may understand someday and perhaps passionately, do not deprive yourself in advance and forever of this opportunity for joy, of this element of development which awaits you in this masterpiece; do not deprive your children! Consider that generations of artists, centuries of love and thought have culminated there, are expressed here. Consider that these stones signify the soul of our nation and that you will know nothing of that soul if you destroy them, that the soul will be dead, killed by you. In a single stroke you will have squandered the fortune of your country—for these are truly precious stones!

I shall not be heeded, I know it only too well. People will continue to break and to repair. Can nothing interrupt this abominable dialogue in which hypocrisy gives the cue to violence and completes the destruction of the masterpiece already mutilated by violence, while protesting that all shall be replaced by a copy, an exact repetition? Nothing can be repaired! Modern men are no more capable of producing the double of the least Gothic marvel than of repeating one of nature's marvels. A few more years of this treatment of the ailing past by the murderous present, and our bereavement will be complete and irremediable.

By our creations as well as by our restorations, does no one see where we are? A while ago we still understood the old styles at our Tuileries and our Louvre museums. We stubbornly imitate them even today, but how!

Tonnerre

The belfries of Laon and of Reims are brothers or sisters.

How each one perpetually recalls the other, and yet what variety between the Cathedrals! How numerous are the Cathedrals, and how unique each one is! Variety in unity; one must not tire of repeating those words. The day when they are completely forgotten, nothing in the French world will be in its place.

It is analogy that binds things and assigns them to their ranks. This tower of Reims is a psalm. This tower: it could be interrupted or continued. What matter, since its beauty is in the modeling?

The Portal.

These figures of bishops are truly capable of hurling lightning; these humble servants who hold the Book; this great majestic figure of a woman, the Law.

The admirable figure of Saint Denis [1] on the north portal carries his head in his hand, and two angels, at the place where his head should be, hold a crown. May I see a symbol here? It is this: ideas, cut off, interrupted in their unfolding development, shall be recovered, shall reign later, in a day that shall have no ending.

The Virgin on the pier,[2] whose face is illumined, is a true woman of France, of the French provinces, a beautiful plant of our garden.

Perfect sculpture of wise, skillful oppositions. The large folds of the cloak of state leave the delicious breast and head in light.

The pier column is adorned with small salient figures. If the details are not Greek, the planes are, and these determine and uphold the general beauty of the composition.

Tapestries of Reims.

These admirable designs, these colors that are as reserved as those of frescoes, this touching story of the Virgin: does not all this bring the soul to flower? And is this not the state of mind that the artist wished to produce? All the backgrounds and the intervals are filled with tiny flowers which, in the tapestry, are fastened to nothing, except to our souls.

These tapestries are works of a supreme art.

And this art belongs to us! The Egyptians, the Greeks—at least so I believe—did not have such works as these tapestries, woven with multicolored grains of dust, the dust of our past! They are like primitive frescoes, Japanese prints, and Chinese vases: in them all is foreseen.

What luxury! And what wisdom in luxury!

Silver-gray enhanced with blue, with red, and still the tapestry matches the stone; it is the color of incense.

One need not know the subject of the composition to judge its beauty. Here Measure reigns; this is its empire, this its throne. But the subjects too, in themselves, contribute an element of beauty of which the embroiderer was admirably able to take advantage.

Here is the presentation of Jesus to Simeon: how beautiful the Virgin's draperies are! This is the Adoration

of the Magi: how well this relief expresses majesty in these royal figures! Next is the Flight into Egypt where the Virgin on an ass is accompanied by angels that are as graceful as those of Botticelli. Here is the Massacre of the Holy Innocents. All these compositions are divided and distributed according to the order of a Pompeian architecture. One feels that he is leafing through a book of hours of incomparable splendor. Perfect full-length portraits complete these *Stanze* of another Vatican. I see again a portrait of a prophet speaking to the multitudes. He affirms, he evangelizes.

A suave gray harmonizes all these tapestries. To their long stay in this Cathedral which they illumine, they owe their hue of the centuries. This thread has the same age as this stone. And those who placed here stone upon stone and stitch upon stitch are collaborators in a single task. The textile and the mineral join together, unite, and are prolonged in love with each other.

Dead leaf heightened in tone; diamond dust; encrusted wheat cockles of a beautiful cherry red; these adorable tones have lived together, are molten, and their union today constitutes I know not what of an unparalleled richness and splendor.

And the draperies, by the style of their folds, make one think of Holbein.

David's gable also has been repaired. Now there is nothing to see. The old gable was visible from below; the new one doesn't give that effect. One feels that the worn-out

spirit could not attain to expression, and this insignificant David is there in place of the original one. It makes no contact with the gaze that rises from beneath.

Romanesque Portal.
The restored part of the door is ruined, lost. The body of the door, despite its wounds, retains all its youthfulness. In place of the molding, since that has disappeared, deeply cut ovolos and darts are substituted.

Statue in the Royal Square.
The statue of Louis xv at Reims is a noble example of the best arrangement. There are fortunate blacks where the figures rest on the pedestal, and the statue itself is admirable in wisdom, irreproachable in its planes; and, besides the beauty of the figures, is that of the tablet, so easily and happily accomplished! Ignorant people, and even some connoisseurs, weary of this sumptuousness, have scoffed at this beautiful work. They are like the bourgeois of the time of Louis Philippe who presume to give a lesson to the contemporaries of Louis xv.

Portrait[3] *of Saint Remi.*
This figure is corroded by the centuries, yet the centuries have not reached what is most precious in its beauty, they have respected the large volumes. And just as it is here, this figure is still the friend of time, and of all times.

It is the sister of those beautiful Greek fragments of which I have seen plaster casts whose first and second

layer of marble, worn, effaced, or destroyed, seem lifted away. From this you expect to find the plane somewhat deteriorated. But it remains visible to him who knows how to look for it, since the plane is the volume itself. Time can do no harm to planes that are true. It only harms the ill-made figures. They are lost as soon as they are touched; wear, from the first stroke, uncovers the falsehood. But a figure that is admirable as it comes from the artist's hands remains admirable however ravaged it may be. The work of bad artists has no duration because essentially it never has existed.

This handsome monument shows all the reasoned and measured power of style.

I always come back to this word "discipline" to define this sober and strong architecture. It reassures and satisfies me. What absolute knowledge of proportions! Only the planes count, and everything is sacrificed to them; this is wisdom itself. Here I reaffirm my soul with something solid that is my own; for I am an artist, and I am a plebeian and Cathedrals were made by artists for the people.

In a particularly imperious way, the sensation of style awakes in me this idea of quiet possession.

The sensation of style. How far it leads! By an obscure route, thought remounts or redescends as far as the catacombs, as far as the source of this great river: French architecture.

For a very long while it was agreed that the art of the Middle Ages was nonexistent. It was—let us tirelessly repeat in order to silence that insult which throughout

three centuries was ceaselessly aimed at it—"barbarism." Even today the most daring minds, those that boast of understanding Gothic art, still have reservations. But this art is one of the majestic sides of beauty.

May the word *powerful* be taken here in its fullest meaning: this art is very *powerful*! I think of Rome, of London. I think of Michelangelo. This art gives France a severe countenance. Only too much time has been lost in seeking an accord between weakness and beauty— "the ideal" of today!

THE CATHEDRAL AT NIGHT

I

Distant gleams turn brown and blacken before certain columns. They clarify others obliquely, feebly yet regularly.

But the depth of the chancel and the whole left part of the nave are plunged in a thick gloom. The effect is horrible because of the indecision of things in the lighted distance. A whole square space is struck by stark illumination; lights flame between columns that take on colossal proportions. And I am made to doubt this epoch and this country by the interruptions, these conflicts of light and shadow, these four opaque columns before me and these six others lighted farther off on the same oblique line, and then by the night in which I am bathed and which submerges everything. There is no softness. I have the impression of being in an immense cavern from which Apollo will arise.

Loches

Loudun

For a very long while I cannot define the horrible vision. I no longer recognize my religion, my Cathedral. This is the horror of the ancient mysteries. At least so I should suppose if I no longer felt the architectural symmetry. The vaulted ceilings are barely perceptible, braced by shadows, the ribs of the arches.

I must escape the oppression of this effect *of closing in*. A guide takes me by the hand, and I move through darkness that soars as far as the vault.

From the light beyond them, these five columns have their oblique illumination. The ribs, the arched ceiling beams, the ogives resemble crossed flags, like those at the Invalides.

I advance. It is an enchanted forest. The tops of the five columns are no longer visible. The pale lights that cross the balustrades horizontally create infernal roundelays.[4] Here one is in heaven by day, and in hell by night. Like Dante, we have descended into hell.

Violent contrasts are like those from torchlight. Ardent fire at the mouth of a tunnel spreads out in layers. Only the columns against this flaming background are indistinctly black. At moments a drapery appears with a red cross; the light seems to be extinguished, but, no, it persists in a mortal immobility.

The chancel is laid bare to horror. But the horror controls itself, imposes order, and this order reassures us. And then, our memory of day, our connections with the day come at this moment to our rescue, giving us the necessary confidence.

There is a reflection on one ogive; the perspective is masked and the clarity, imperfectly developed on the edge, shows only the stationary construction in the dim gleam. But this gleam, although terrible, nevertheless reveals the masterpiece.

The Cathedral assumes an Assyrian character. Egypt is vanquished, for this Cathedral is more poignant than the Pyramid, farther from us than the grottos where the great creation of rules appeared. The unknown is the mystery of this spectacle. One thinks of a forest, of a grotto, but this is nothing of that sort: this is something absolutely new, which it is impossible to define at once.

The frightful bulk of night, feebly pushed aside for a moment, as quickly, and with an irresistible violence, regains empire.

This is like Rembrandt, but *as a spectre of taste and of order*. Rembrandt himself brings us not more than an echo of this prodigious world.

I am in terror and in rapture.

Dante, did you enter this circle of horror?

The chapels are transformed by the struggle between darkness and light.

This one is a somber grotto where there seem to be only shells set out along the ribs of the arches. And yet, the terrible shadow allows itself to be seen, appreciated, and modeled.

Another chapel is divided in two by a cast shadow. One whole side is abolished. The columns seen from

three-quarters, black and formidable, disturb the whole architectural arrangement. My dissipated mind apprehends only frightful things; it sees horrible supporting legs repeated in this forest that man has created for his God. Is this forest less beautiful than the real one? Is it animated by fewer thoughts, less populated by atrocious larvi and by fewer spirits?

And you, gargoyles, did you not issue from the brain of sculptors who returned to the Cathedral after sunset to take counsel there from night and to seek there the memory of some horrible dream?

I aspire to a new confirmation of the grandeurs of the Gothic soul.

One would have the impression of a Tower of Babel if, in this apparent confusion, all at once architectures did not surge out of the night, if the shadow itself were not organized. The moment is present without words and without voice.

Completely black columns are around the chancel; this is stone in prayer, a waterspout that rises to God.

Oh Night, you are greater here than anywhere else. It is because of the half illumination that terror comes over me. Incomplete illuminations cut the monument into trunks, and these gleams tell me the thrilling pride of the Titans who built this Cathedral. Did they pray? Or did they create?

Oh genius of man, I implore you, remain with us, god of all reflections!

We have seen what the human eye had not yet seen, what is perhaps forbidden it to see. Orpheus and Eurydice feared being unable to escape, since the boatmen did not come to fetch them in the terrible gloom. We walked alone amid Night. We were in the straits of Tarn. We went alone into a great forest. A whole world was in this Night that the Titans had prepared for us.

A candle burns: a tiny point of light. To reach it I must stride over heavy masses of shadow where I rub against dead gleams, unicorns, monsters, visions.

The Thinker [5] would have been well adapted to this crypt; this immense shadow would have fortified that work.

By lighting a candle, the sacristan has displaced the shadows.

There is a treasure here, the treasure of shadow accumulated by night. It hides the treasure of the Cathedral. [6]

As we reached the door, this gigantic scene advanced toward us: the immense room seemed prepared for a banquet to the infernal gods.

Then the small door of the Cathedral was closed. The vision disappeared. All is entrusted now to our memory.

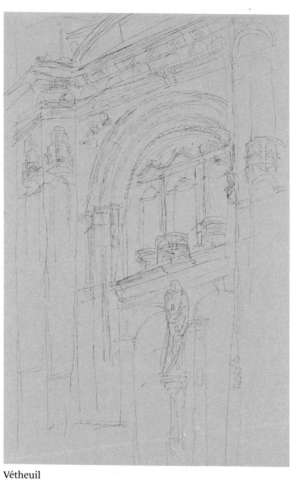

Vétheuil

II

From my window.

Before making my way toward the Cathedral to pay it one more nocturnal visit, I contemplate it from the window of this room which I have chosen because it is very close to the colossal wonder.

Constructions charged with thought! Accumulation of thoughts over this facade, this bas-relief of which from my window I see but one part. What race of men made this? Thousands of years, centuries have their portrait here. This is a visage of human infinity.

Inside the Cathedral.

From the depths of the nave, from the chancel as a whole, one feels repulsed by shadow out of which, hollow and confused, come terrifying forms. And I believe I hear an irritated voice reprimanding me:

"Who dares to invade my solitude? Am I not the Virgin of Night? Are these shades no longer my own? Who dares to enter here?"

I felt that I violated the rights of silence, that a sacrilegious hand opened to me the heart of this holy silence. But an artist is able to understand, and he is not a profane outsider here.

Everywhere one feels unalterable foundations. All is security. The pillars are certitudes. This is admiration transfixed, congealed into lordly columns all aligned like an army.

The pillars, reassuring in all their dimensions, are more real the closer they are to the ground. There are effects of light on the stone pavements. The small columns appear to be pleated.

Other columns are like trees that uphold the vault and the sky, that lift the antique night. Again they force upon me the image of ranks of disciplined soldiers. They are bordered with light. They stand erect like a wood; their type is a beechwood. Above, one sees only the design of their branches. Silence accompanies their moldings as far as the pinnacle, the silence of immobility, for the wind here causes nothing to move, and these trees are indoor plants. Along the height of these columns, of these trees, feeble gleams mount which will be lost in the shadow of the vault. In their lightness, the ribs appear as lofty spiderwebs.

In short, these pillars set out in an arc directly support nothing but shadow, only black clouds. Starting from the feebly lighted base, their shafts terminate in the unknown. And yet, the ceiling restores truth up there, which the shadows uphold. I have above my head an abyss of height, but an abyss so well ordered that illusion harmoniously shifts its emphasis when the lights move.

This Renaissance pillar is not completely lost in that abyss. It grows spindle shaped in rising and is delicately enclosed in the somber cloud. One feels that high up there, above black rocks, firebirds furiously beat their wings; there is a struggle, and from that conflict of forces, order is born.

Blois

I am at the heart of a pyramid.

How strange that a tiny candle flame should be able, as it vacillates, to make the monster palpitate, should move architectures which at this moment are immobile! A slight variation of light, and all this will move.

Short prelude; a peal: voice of the minute.

This chant, up there, is like a warning for the angels; in the half-light, time immemorial is about to ring.

The bell, sound of forges, the swinging of small bells pour vibrations over all.

From my window.

Looking again at the Cathedral through my window, I see a curtain of stone whose sculptures are its embroideries. Faust would deserve the privilege of living in this room, by this window, in the shadow of the portal of the masterpiece whose splendor exalts this street, this city, this country.

The immense bas-relief is still there in the darkness; I cannot distinguish it but I feel it. Its beauty persists and, triumphing over shadow, allows me to admire its powerful black harmony. The bas-relief overbrims the bay of my window almost hiding the sky.

How explain that the Cathedral, even wrapped in veils of night, loses nothing of its beauty? Can the power of this beauty possess us beyond our senses? Does the eye see without sight? Is this prestige due to the virtue of the

monument, to the merit of its immortal presence, its tranquil splendor? A marvel acts upon the sensibility beyond the restricted domain of a particular organ, thanks to the intervention of memory. A few reference points are sufficient, and the alerted mind, accepting the work's legitimate authority, opens to its sublime influence and recognizes, despite imprecision, the regularity of the general form. And yet the mind does not succeed in deciphering all. It awaits revelation.

ANOTHER VIEW OF THE CATHEDRAL
I walk in remotest antiquity.

Below, a small light outlines a crown, and the columns seem the columns of Night.

A light carried by the sacristan penetrates the gloom like a ploughshare driven through clods of earth. Light bears down, and the shadow quivers to the left and right; it passes, and the blocks of shadow close again over this gleaming furrow.

Above are crumbling stalactites of shadow! These fall into a swamp of shadow which itself augments in contrast to the light. One seems to walk in a forest at night beneath trees of winter. Glimmers accumulate in the between-columns, drawing curves that transect each other, and yet one remains lost in obscurity. I repeat that, if one did not hold on to the feeling for order amid perspectives sketched by the errant light, fear would be invincible.

The top of the monument is marked by long gray

streaks. At the base, gleams filter through. And for all my struggle, I discover nothing. I bang against the impassive wall, the sublime wall where no detail appears, which all the same gives me the sensation of modeling. Morning, the revealer, when the monster sleeps no more, will tell us what veils, what triple veils, hid from us the sight whose splendor I divined. For the moment I owe as much to my imagination as to my eyes. I stand before an impenetrable mask.

The small light that moves, step by step, evokes the idea of a crime. In this way a dim lantern would accompany the steps of a criminal.

Man's genius triumphs in the creation of arcades. From where did this idea come? From the rainbow perhaps?

Transept.
I seem to see the staircase of Chambord developed to vast proportions. Spirals pass into the heights, bridges are outlined whose bases plunge into the shadow of the transept cross.

These great roses, the stained-glass windows, these suns by day, are by night more black than all the other parts of the Cathedral.
 The chapels are the alveolus cells of a beehive.

Shadow flattens the pilasters. Here and there are streaks

less black. One distinguishes graduated forms which the confused light masks without regularity, especially when I look from the three-quarters view. The imposing richness of gray and black remains.

Purity and lightness result from this: that the prismatic form always lights masses by a sharp edge.

Exterior of the Cathedral by day.
Through the open doors, above the white columns springing toward the vault, the stained-glass windows on bright days are Persian images. And the group of columns, seen beneath the arcades and the vaults, seem pushed away by the back windows.

From my room, all bathed in shadow cast by the Cathedral, I see from my bed the vast bas-relief; this is one part of the facade. And my whole room, like my thought, is engulfed in this work which draws me. I think of the thousands of men who have worked at *that*.

Very few living today pay homage to this desert of divine stones that were formerly so much admired. I come to them, led by the love that defends us both from death. I feel I am the sundial's needle, continuing to mark the vital and glorious hours upon the dial of humiliated centuries.

What friendly breeze refreshes my brow? It is the wind that has just touched the Cathedral. Hardly any others than the wind and I have remained faithful.

Weary, I had started back toward my room and was taking, nevertheless, one hundred steps before going in; the sun stretched its rays to infinity, and all at once the Cathedral *allowed itself to be seen*! The marvel of marvels had waited for me to brim my heart, my soul, and brain with its splendor, to strike me with its divine lightning and its magnificent thunder. I was alone before the colossus. Moments at once of annihilation and of extraordinary life! Sublime apotheosis! Sacred terror! Unexpectedly, light reveals the unexpected.

Things appeared to me more lofty, purified. They faded to nothing, transformed by glory. Lights that emphasized the first planes were interrupted to take more power in following the ascendant lines, leaving the porches to fill with mist, to be dissolved in shadow, while beyond, the Cathedral thrust its audacious framework to heaven.

Exterior of the Cathedral at night.
These guardians of shadow over the door forever, these great witnesses, this guard of honor in three ranks—by four, by six, by ten—these saints seem to be resuscitated souls standing in their tombs.

Throbbing about these strange figures, I feel a soul that is not from among us. What a terrible enigma they are to me! They seem to be bearing witness, they live the life of the centuries. Are they apparitions? They have a for-

midable religious intensity. Do they not of one accord await some grave event? They are no longer of the time of their carving. Their aspect constantly changes, and for me these figures have a singularly new and foreign accent. I think of Hindustan, of Cambodia.

1 This figure carrying his head is on the north transept portal, *Portail Saint Sixte*. It portrays Saint Nicaise, not Saint Denis. Opposite on the same transept portal is an inferior portrait of Saint Denis with his head on his shoulders, a late work. [All notes in this text and the one following are by the translator unless otherwise indicated.]

2 A pier is an isolated mass of masonry, a large column, like those between the nave and its aisles, as distinguished from the more slender columns.

3 The French word here is *portail*, but there is no portal of Saint Remi at Reims. The subject of this page is the beautiful portrait of Saint Remi at the left angle of the north portal on the principal west facade of the cathedral. See E. Moreau-Nélaton, "La Cathédrale de Reims," *Beaux Arts*, 1915, p. 105, planch 52.

4 Dances in the round. See Albert E. Elsen, *Rodin*, The Museum of Modern Art, New York, 1963, pp. 155–156.

5 This refers to Rodin's enlarged figure of *The Thinker*.

6 The French word here is *église* (church), but obviously it refers to the Cathedral of Reims.

Ornaments

The decoration of our churches is the work of centuries, the slow, meditative collaboration of several currents. Here man seems to have obeyed mysterious influences, laws that he *could not* transgress. He has made these works of art as the bee makes its honey, by a happy fatality.

With one difference, however. Upon a given theme man varies but exhausts himself, while the docile beasts repeat themselves tirelessly. When man reaches the end of one of his ways, there is decadence, natural night; this process was as necessary as day itself. Humanity would perish if it always used its genius in the same way, if it knew no repose of change, if it did not submit to the alternatives of death and of rebirth to which the science of our epoch attests. In any event, it is sure that man reaches repose by being spent, and we, in our history, have reached such a phase. How slowly regeneration comes!

How many studies to recapture ancient thought in its purity! This requires an excavation not in the earth, but in the sky for, although offered to the sight of all, although in full light, that thought remains more profoundly buried than if there were need to struggle for it in the bowels of the earth. One may say that today light makes a winding sheet of all that beauty.

What is most difficult is to think, not with the primitive ingenuity of childhood, but with tradition, with acquired power, with all the resulting, hoarded treasure

of thought. Indeed, the human mind cannot go very far except on this condition: that the thought of the individual be added, with patience and silence, to the thought of generations.

But modern man no longer takes account of the thought of generations.

The art of the Middle Ages, in its ornamentation as well as in its constructions, derives from nature. It is therefore always to nature that one must go for an understanding of that art.

See Reims: in its tapestries we find the same color, leaves, and flowers as in its capitals. This is true of all the Cathedrals.

Then let us give ourselves the joy of studying these flowers in nature, that we may have a just notion of the resources which the decorator of living stones required of them. He penetrated the life of flowers by contemplating their forms, by analyzing their joys and their sorrows, their virtues and their weaknesses. These are our sorrows and our virtues.

So flowers have given the Cathedral.

To be convinced, go into the country and open your eyes.

At each step you will have a lesson in architecture. Men of yore looked before us and understood. They sought the plant in the stone and now we find their immortal stones in the eternal flowers. And (is this not the greatest homage they could have hoped for?) nature, al-

though certainly without taking account of our dates, ceaselessly speaks to us of the twelfth century, of the fifteenth, of the fourteenth, of the eighteenth. This is because nature takes it upon herself to defend from all criticism the anonymous artists of those great epochs.

For me, these beautiful studies in the open air are beneficial. My room hurts me as shoes a size too small would hurt my feet. And how much more the city, the new city! It is in the fresh air of the fields and the woods, I must repeat, that I have learned all that I know.

The flowering fields of Verrières.
As if thrown all at once into this immense garden in the beautiful sunshine, I feel myself live through my eyes a new, more intense, and unknown life. But so much splendor makes me dizzy. These flowers that a horticulturist grows for the seeds in massive squares filled with plants all alike, these juxtaposed layers of color, create an impression of stained glass and make me live with them.

It is too radiant. My powers are insufficient. I cannot endure the sudden burst of this beauty, of this motionless beauty!

I run for refuge to shelter myself in the simple greenery where a fresh breeze, a zephyr, gently makes the leaves of my notebook tremble.

My intimidated eyes have nevertheless received and retain the impression of this stupefying magnificence. Only fifteen days ago it was almost winter, and suddenly

all is burgeoning, the clouds and the trees like the flowers. This is a mad abundance, a turmoil of youth! Dazzling opulence. One dare not choose among so many treasures. For study, one needs a more restricted field.

In one flower almost all flowers are given. In the least walk through the country, it is nature as a whole that one meets, and all grassy ways are the paths of paradise.

To be sure, I am only a botanist who has missed his calling. Nevertheless I understand in my way. While "autos" spread their noise and their dust from the roads, I study, bent to the wild flowers of my path.

What curious, varied, and innumerable expressions are available to an artist!

On unequal planes, all flowers are equal; the small and the large have the same dignity.

It seems that in the morning it is easier to distinguish between them by the tips of the stems. This is the moment when flowers turn their backs to us so gracefully!

There are some that shine in splendor when they spread the ornament of their petals. Ah! floral ornament, what priceless counsel to sculptors!

Many plants imitate birds by flying in place. Attached to the stem, but very separated from each other, the leaves flutter.

Other leaves hang like flags at half mast. Still others are like cloths suspended from windows.

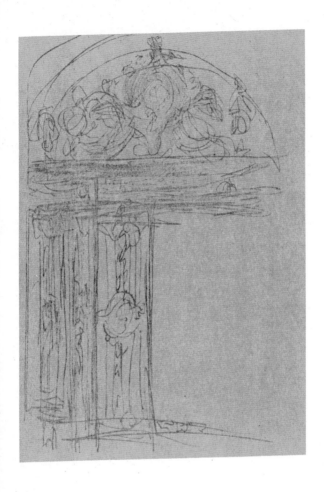

Study

Blois

Little flowers that I have met in the gardens and woods, you have allowed me to make such observations as you granted to sculptors and stained-glass workers during the time of beautiful ornaments.

These two leaves, one at the right, the other at the left, pucker, become fluted, and join together. At their base grow two others, then two still smaller ones, and so on. They cast up from their hearts two small stalks that separate, carrying two flowers, two buds, and a group of smaller buds.

How precious are the veins of these leaves like delicate fans! And they are only wayside plants.

A little rose window of chalices. Flowerettes around a somber flower.

Certain wildflowers have helmets like Minerva.

The fibers of plants begin in delicate and clearly defined nerves following the principle of the stalk, springing up and entering the leaf as they run without stopping.

These leaves that fold back, that make a half turn upon themselves, that close at one-third, and then allow their edges to escape and be regathered. The flounce of a dress.

The stem that carries them is grooved like a column.

Boughs toss this way and that expressing various sentiments which never forget to be graceful.

These felled trees, outstretched, are moldings. Certainly their value is Gothic: expressed in the round.

Its whole root was in my hand. But communication with the earth was interrupted. Love cannot accept separation. Why should we be astonished that it was dead in less than half an hour? Could we live longer than this plant, far from the elements necessary for our life?

When a leaf is going to die, its partitioned surface becomes more sensitive, more salient, like the veins of an old man. It twists about itself and shrinks. But these transformations leave it its beauty, and its morbid modelings are those of a Gioconda.[1]

Then it lets go and falls without resistance.

See, these flowers are in a state of catalepsy. When the leaf grows old, it has the aspect of an artificial flower. Its soul has evaporated. Always in this manner a flower stiffens, hardens before reaching madness, the death of the petals.

In youth, the flower draws in, assembles its petals, hiding its heart. In age, lamentable; if one holds it straight up, it falls, the petals outspread. But in dying it produces life.

Is society transformed in the same manner? We be-

lieve that all is lost and do not see the good, the work that prepares the fruit, as our death or our illness produce life or health.

When flowers fade they lose reciprocal respect, they touch each other, jostle and fall over one another. In good health they always keep a distance between them.

They hold themselves upright, but with flexible elasticity, with I know not what of an airiness, something like the elastic and smilingly balanced equilibrium of a dancer who seeks the homage that she calls forth. What uninsistent beauty and always quick to offer itself!

 I believe they are proud of their sovereignty and I adore their self-esteem.

Two ailing flowers: one leans over the other in passing in front of it, and this one upholds her sister, itself bending also. There is sadness and tenderness here.

At the point where the stem is noded and sends out its digitation into membranes, the leaf embraces the stem, then, assured of a solid point of leverage, throws itself backward.

Gable ends are always formed like the apexes of plants.

Tulips.
They fling themselves, they spread out like happy

courtesans; with a free movement, they bare their hearts which may not be chaste, but are indeed adorable.

This one, fallen, the "muzzle" wide open, has fainted.

That other one hangs in a plumb line. Its shuddering of distress, which I see despite its immobility, marks the madness of the flower; old age.

The most wealthy of the three Magi and the Queen of Sheba were not more sumptuously attired than this tulip of mixed gold and red.

And this, also gold and red in another design, is this a bird of the Islands? Is it not rather the wing of the Archangel Gabriel?

And in almost all I seem to find the gesture of a Sappho, the gesture that provokes and that gives. It persists even in those that have fainted, that hang their heads before them. They also seem to be colored bubbles floating in air.

And here are some that are appalling: these bloodred tulips streaked with gold are like flayed living flesh in full sunlight; in places they give the feeling of spoiled meat. These thongs, so delicately lacy, and lately so beautiful, are now rotted fibrous things. No more yellow-gold at the heart. A horrible wound of coagulated blood, a morsel of carrion, this red as of a disease that burns, this mucus that oozes. Lamentable flower that frightens us! And yet it is not dead; it suffers the transformation necessary to fructification. Is this the image of our death?

Moldings

In certain tulips there is a whole marvelous sunset.

Between their petals one makes out a bleeding crucifix.

As for this one, it has lost its shape. Life is concentrated in the stem from which the flower droops sadly. Its pistils protrude beyond the petals like the paws of a lizard. But the flower still has its bursting eucharistic reds, gleaming as if these petals had been carefully brushed. This tulip has the richness of Oriental silks, of silks from Genoa.

Lacy tulips. Their red and yellow petals are like incendiary flames; curly at places, they suggest fire tormented by wind.

For there are flowers that burn. These are in full incandescence. Leaning out of the vase that supports their stalks, these tulips blaze in the air. One might be looking at flames driven by a gale that comes from all sides.

And there are flowers that cast spells. Do they not project a fluid?

It is particularly to its leaves that the white daisy has encrusted its beauty. While the stalk rises, the leaf is designed at first as a notch, then higher two more larger notches, and each one of these has the form of a little tongue.

The privileged leaves will have the joy of encircling the pride of the whole plant: the bud, which is already superb in its transitory planes and will be a flower that is very beautiful in its simplicity.

The daisy that resembles the sun is the flower of children and of lovers. The lover gives it to poets and to artists.

In its mounting leaves, the daisy simulates the form of an openwork vase in wrought iron. It curls up when it bends, faded. It leans, and when it is about to fall, it is a little hand, a small paw with too many curled fingers. Several faded daisies: little cut-out valances.

When young and fresh, this flower is an admirable principle of decoration. All ornament makers of the best epochs have studied it. Its leaf is the French acanthus.

The lily-of-the-valley flowers at the same time as the cowslip because the beauty of these two flowers destines them for symmetrical places in the bouquet of the beautiful season.

Each one of them is very feminine.

Another woodland flower evokes a flat-bottomed canoe with its rowers. It bends an elbow to turn back upon itself.

I am not familiar with this plant whose leaves are all ink stained. Might this be the scholar's flower? Or the scribe's?

The violet leaf is in the form of a heart.

Honeysuckle has little green leaves like lentil leaves; its stem has four angles, like the church of Saint Gudule.[2]

This little clover, that has been ironed at this very instant, remains pleated in the manner of holy vestments.

Dandelion, wood sorrel, lance head, halberd.

The petals of this blue pansy are a dark blue velvet and cream-colored silk chasuble.

The lilacs are so fresh! They seem to offer a glimpse of beautiful weather.

Their leaves, a little wavy with inconsistent shadows, are full of vigor.

The carnation is the flower of Louis xv. It was worn in knotted ribbon on slippers. But earlier the Gothics carved it where the arcs of the vaulting surfaces meet.

This dandelion shows us all that it has in its belly! It thinks only of reproduction.

The wild forget-me-not has a slightly dizzy air. It has not much memory; it is too small.

The weed: oriflamme, golden flame, a bright and glorious banner, inspiring courage and devotion.

The leaf of the cherry tree has vivid touches on its upper surface. This is an essentially Gothic leaf; you will often find it in the plaster casts of the Trocadéro museum.[3]

The plantain, that weed of "coupasse" that is used for cuttings,[4] is a spear upheld on both sides. Its leaf is singed.

This eye of the anemone is angry and bloody. I know nothing more heart gripping than this flower. The one I am looking at is at the critical age; it is covered with fine wrinkles; its petals are as if disjointed; it is going to fall. The Persian vase in which I have placed it, blue, white, and cream, makes for it a worthy tomb. Its sisters in full bloom are designs for rose windows.

This large flower, of the violet color that I love in certain stained-glass windows of Notre Dame, touches me like a memory, especially now that we are returning to God, this flower and I. Its sad heart, where a black bud is forming, is also encircled by a black crown which the petals exaggerate, and these violet petals make the window seem to stand before the light. This flower is a widow.

All my flowers are there, beneath my eyes, answering my call.

Yesterday I saw among them arms, hands, and profiles.

Today they draw themselves up like the branches of candelabra, offering to hold lights. A single one has fallen and hangs like a dead snake.

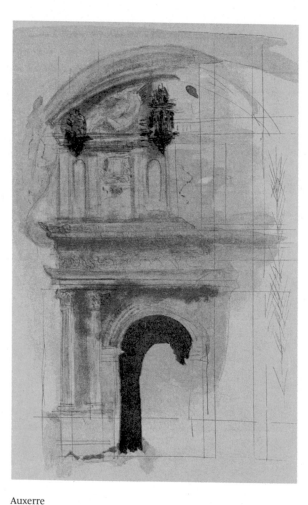

Auxerre

There is no doubt that the beauty of flowers and their movements express thoughts; as our own movements and our beauty. But flowers speak in chorus; they have only a collective consciousness, only unanimous thought.

Thus they command us not to lose the feeling of the whole, even while we take advantage of the charming details that they allow us to see.

All these flowers, and many others, indeed all others, have served as models for sculptors and stained-glass workers. As the painter-stained-glass worker took his hues from them, the sculptor took his harmonious joinings.

Glass worker, you have crucified the flowers in your bloodred windows of the Passion.

1 Ed. note: In her copy of the Beacon Press edition (1965), the translator in-serted a handwritten annotation following "Gioconda" that reads, "For American readers, the Mona Lisa would perhaps be a better translation."

2 In Belgium.

3 Now the Musée des Monuments Historiques.

4 Used to mix with or "to cut" certain medicines.

AUGUSTE RODIN (1840–1917) was a French sculptor known for his naturalistic bronze and marble figures that privilege emotive pathos over allegory. His attention to fragmentation and the visible traces of his process in the final works are hallmarks of his groundbreaking and influential style. Turning away from the idealistic forms of neoclassical sculpture, he began his career in Brussels and later returned to Paris, where public commissions allowed him to pursue his own aesthetic experimentations. A frequent notetaker, Rodin wrote only one book, *Les Cathédrales de France*. Rather than taking the form of an architectural treatise, the book was compiled through periodic visits to cathedrals across France, where Rodin recorded his observations as well as quick pen and pencil sketches, intending to reinvigorate public sensitivity to the solemnity and majesty of France's Romanesque and Gothic heritage. As Rodin believed that an individual's character was revealed by his or her physical features, the cathedrals became a model not just for the human figure but for the consciousness of a rapidly modernizing nation-state at the turn of the twentieth century.

ELISABETH CHASE GEISSBUHLER (1901–2001) was twenty years old when she moved to Paris from Boston to study sculpture under Antoine Bourdelle. Also studying with Bourdelle at the Académie de la Grande Chaumière were Alberto Giacometti, Betty Parsons, Margaret Cossaceanu, Otto Bänninger, Marko Čelebonović, and Arnold Geissbuhler, her future husband. Bourdelle had been Rodin's close friend and collaborator. When Geissbuhler translated Rodin's *Cathedrals of France* in 1965, she was already a recognized Rodin scholar. She continued her exploration of Rodin and his philosophical and artistic influences until her death in 2001. Other works by Geissbuhler include *Rodin: Later Drawings*; essays such as "Rodin's Abstractions: The Architectural Drawings," in *Art Journal*, and "Rodin's Drawings of Architecture," in *Auguste Rodin: Drawings and Watercolors*; and the translation of *Intimations of Christianity*, by Simone Weil.

RACHEL CORBETT is the author of *You Must Change Your Life: The Story of Rainer Maria Rilke and Auguste Rodin*, which won the 2016 Marfield Prize, the National Award for Arts Writing. Her essays and journalism have appeared in *The New Yorker*, *The New York Times Magazine*, *The Atlantic*, and *New York* magazine, among other publications. She wrote the introduction to Rainer Maria Rilke's *Letters to a Young Painter* (2017), published by David Zwirner Books.

"Ekphrasis" is traditionally defined as the literary representation of a work of visual art. One of the oldest forms of writing, it originated in ancient Greece, where it referred to the practice and skill of presenting artworks through vivid, highly detailed accounts. Today, "ekphrasis" is more openly interpreted as one art form, whether it be writing, visual art, music, or film, that is used to define and describe another art form, in order to bring to an audience the experiential and visceral impact of the subject.

The *ekphrasis* series from David Zwirner Books is dedicated to publishing rare, out-of-print, and newly commissioned texts as accessible paperback volumes. It is part of David Zwirner Books's ongoing effort to publish new and surprising pieces of writing on visual culture.

OTHER TITLES IN THE *EKPHRASIS* SERIES

On Contemporary Art
César Aira

A Balthus Notebook
Guy Davenport

Ramblings of a Wannabe Painter
Paul Gauguin

*Thrust: A Spasmodic Pictorial
History of the Codpiece in Art*
Michael Glover

Visions and Ecstasies
H.D.

Pissing Figures 1280–2014
Jean-Claude Lebensztejn

The Psychology of an Art Writer
Vernon Lee

Degas and His Model
Alice Michel

28 Paradises
Patrick Modiano and
Dominique Zehrfuss

Summoning Pearl Harbor
Alexander Nemerov

Chardin and Rembrandt
Marcel Proust

Letters to a Young Painter
Rainer Maria Rilke

Giotto and His Works in Padua
John Ruskin

Duchamp's Last Day
Donald Shambroom

Photography and Belief
David Levi Strauss

The Critic as Artist
Oscar Wilde

Two Cities
Cynthia Zarin

FORTHCOMING IN 2021

The Salon of 1846
Charles Baudelaire

The Cathedral Is Dying
Auguste Rodin

Published by
David Zwirner Books
529 West 20th Street, 2nd Floor
New York, New York 10011
+ 1 212 727 2070
davidzwirnerbooks.com

Managing Director: Doro Globus
Editorial Director: Lucas Zwirner
Sales and Distribution Manager:
Molly Stein

Project Editor: Elizabeth Gordon
Proofreader: Anna Drozda
Design: Michael Dyer / Remake
Production Manager: Jules Thomson
Production Coordinator:
Claire Bidwell
Printing: VeronaLibri, Verona

Typeface: Arnhem
Paper: Holmen Book Cream,
80 gsm

Publication © 2020
David Zwirner Books

The texts in this volume by Auguste
Rodin were first published, in
French, in Rodin's *Les Cathédrales
de France*, in 1914. The English
translation, *Cathedrals of France*, by
Elisabeth Chase Geissbuhler, was
first published in 1965 by Beacon
Press, Boston. A revised edition was
published in 1981 by Black Swan
Books, Redding Ridge, Connecticut.
The present volume reprints texts
from the 1981 edition, with minor
additional revisions made by the
translator.

All drawings are by Auguste
Rodin and first published in
Les Cathédrales de France, 1914.
Musée Rodin, Paris (Inv.6758).
Photography by Jean de Calan.
© Musée Rodin

Distributed in the United States
and Canada by
Simon & Schuster, Inc.
1230 Avenue of the Americas
New York, New York 10020
simonandschuster.com

Distributed outside the
United States and Canada by
Thames & Hudson, Ltd.
181A High Holborn
London WC1V 7QX
thamesandhudson.com

ISBN 978-1-64423-046-6

Library of Congress
Control Number: 2020911576